FLOWER AND DOODLE DESIGNS

WOLF
COLORING BOOKS FOR ADULTS
STRESS RELIEVING PATTERNS

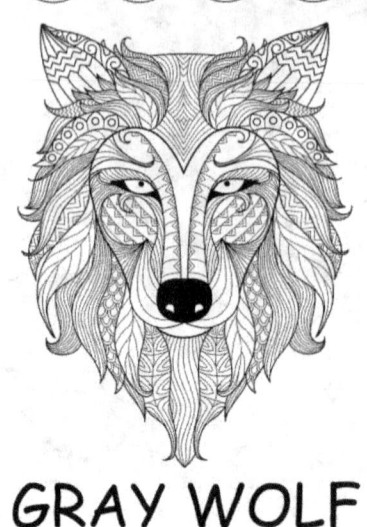

GRAY WOLF

Copyright 2017
Printed in The U.S.A.

All right reserved. This Coloring books or any potion thereof many not be reproduced or used in any manner whatsoever without the exoress written permission of the publisher except.

1.

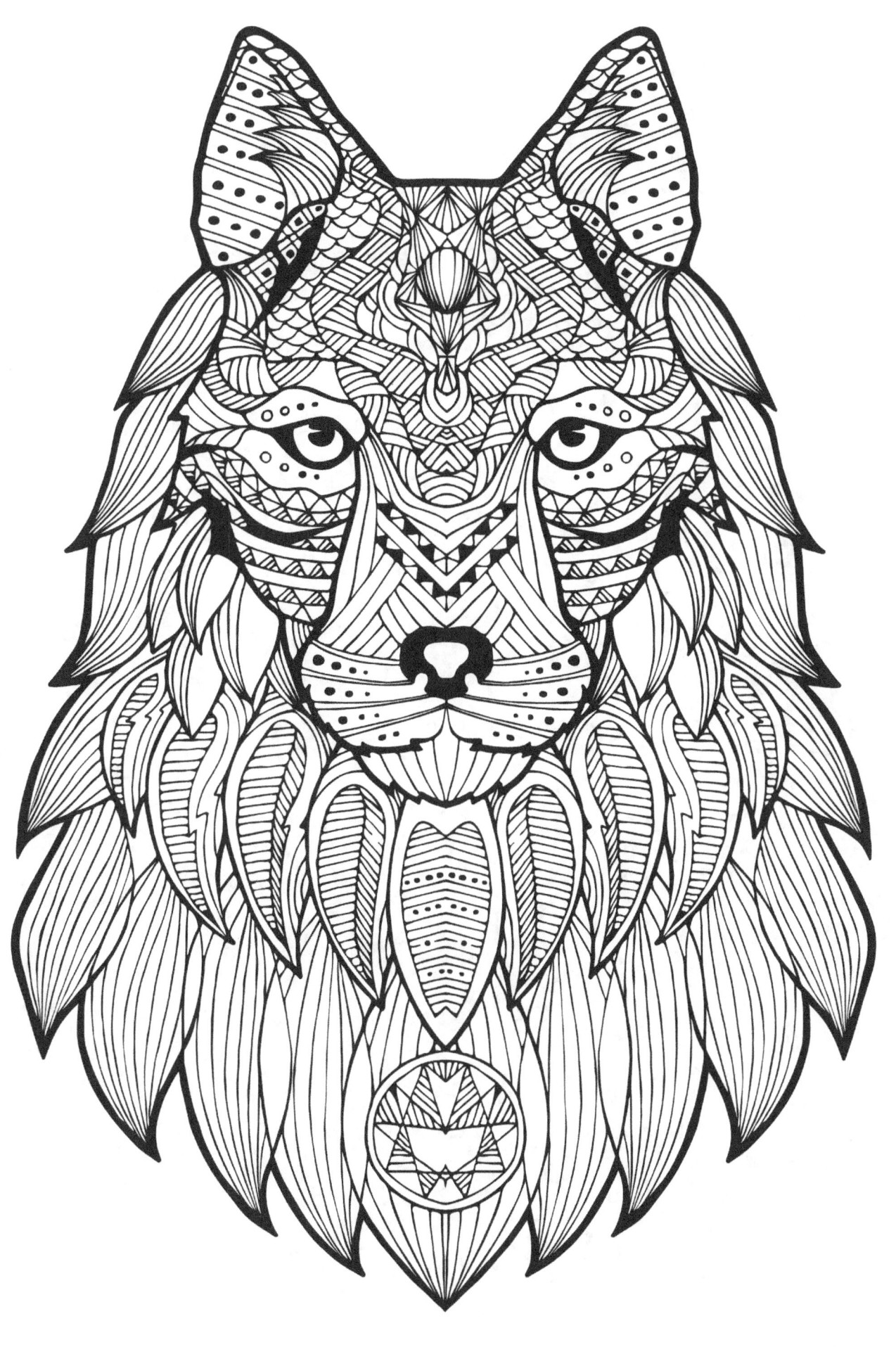

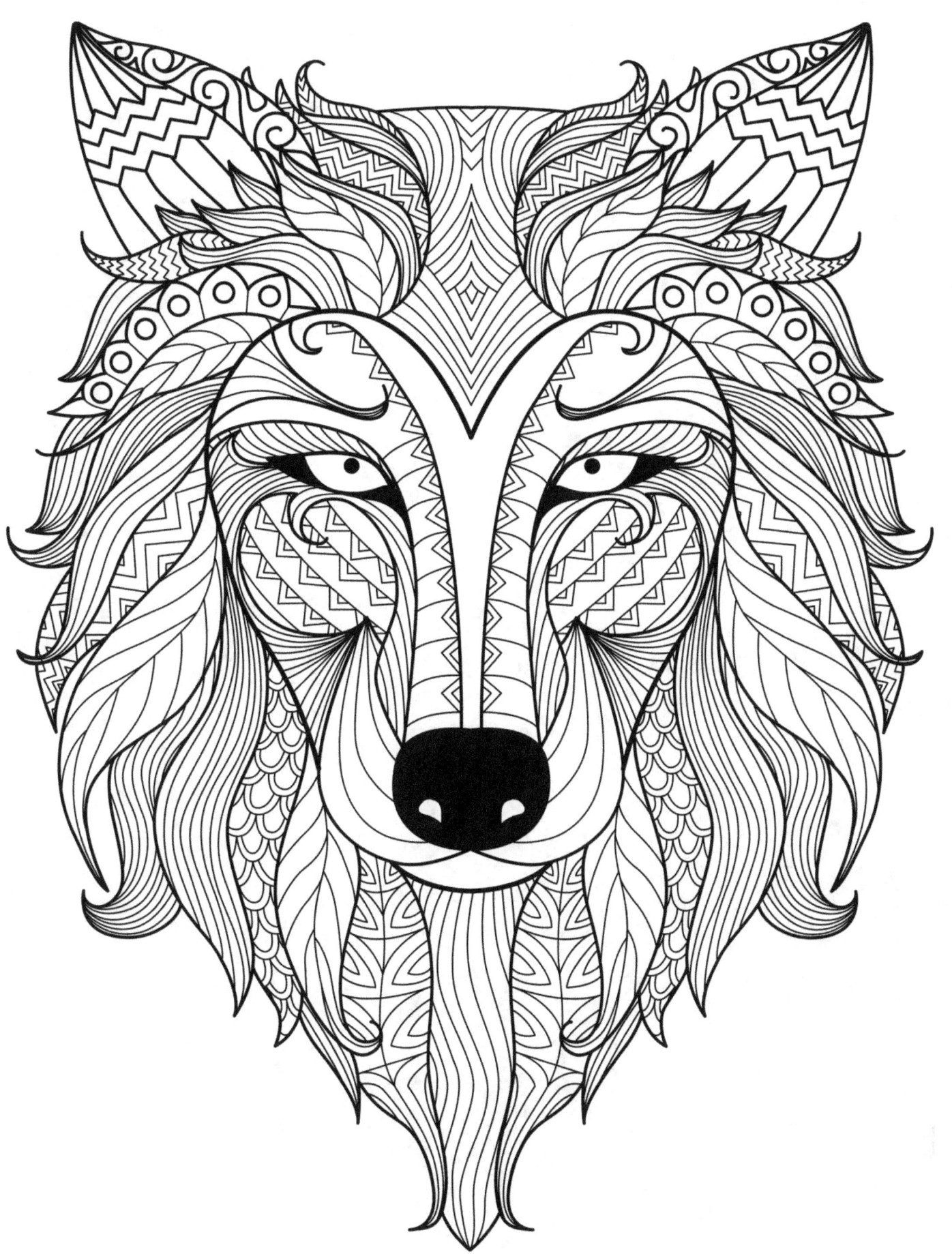

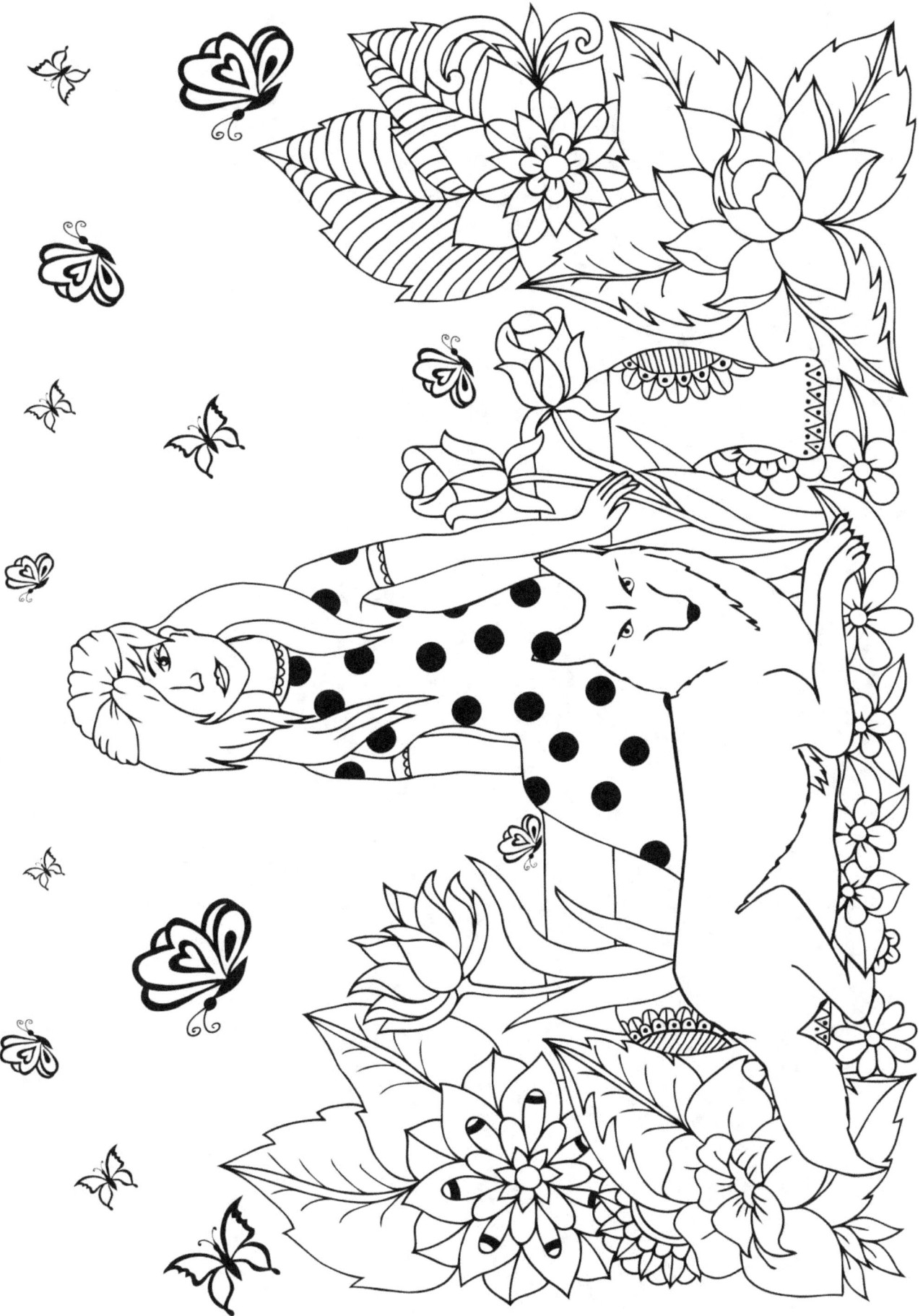

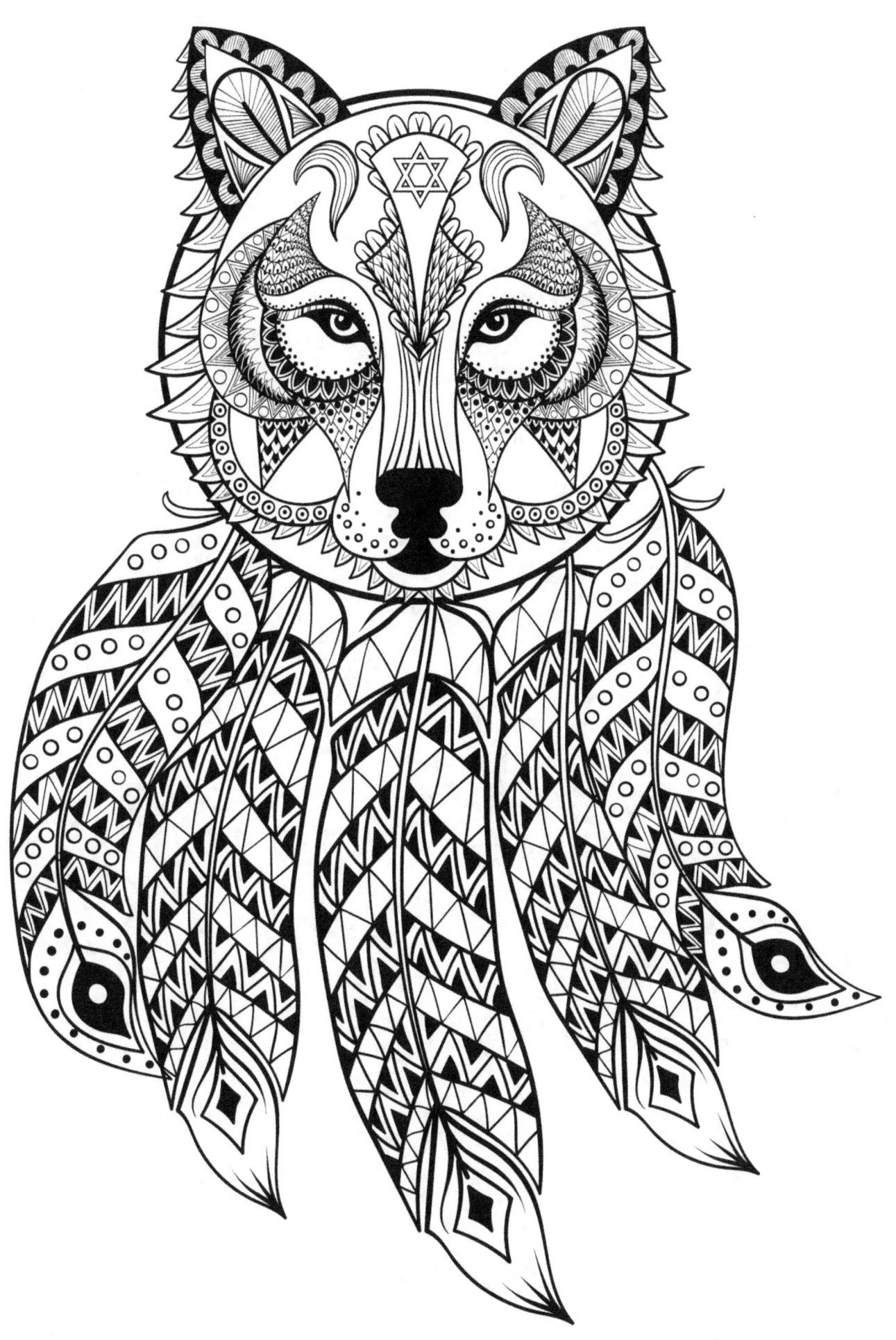

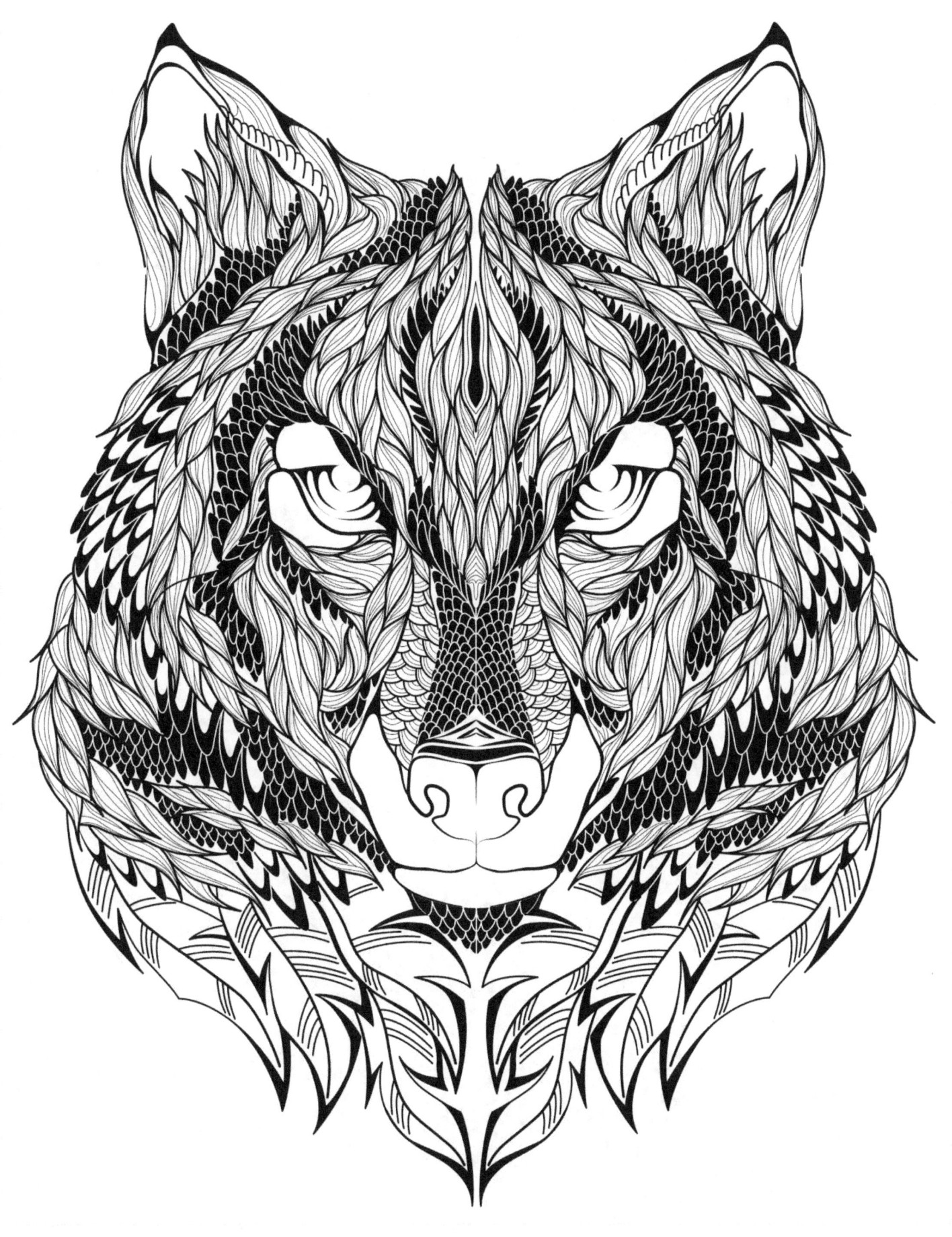

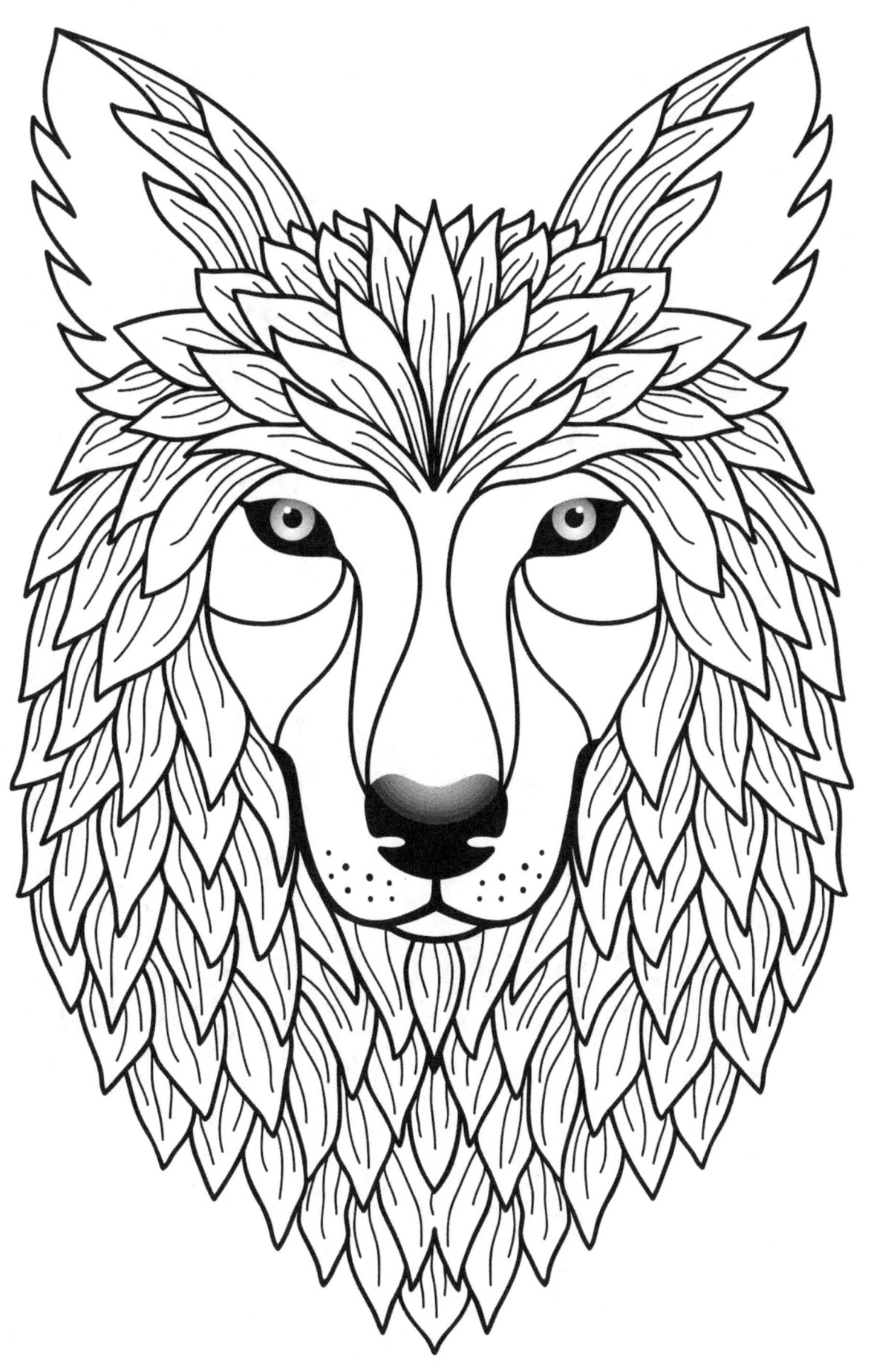

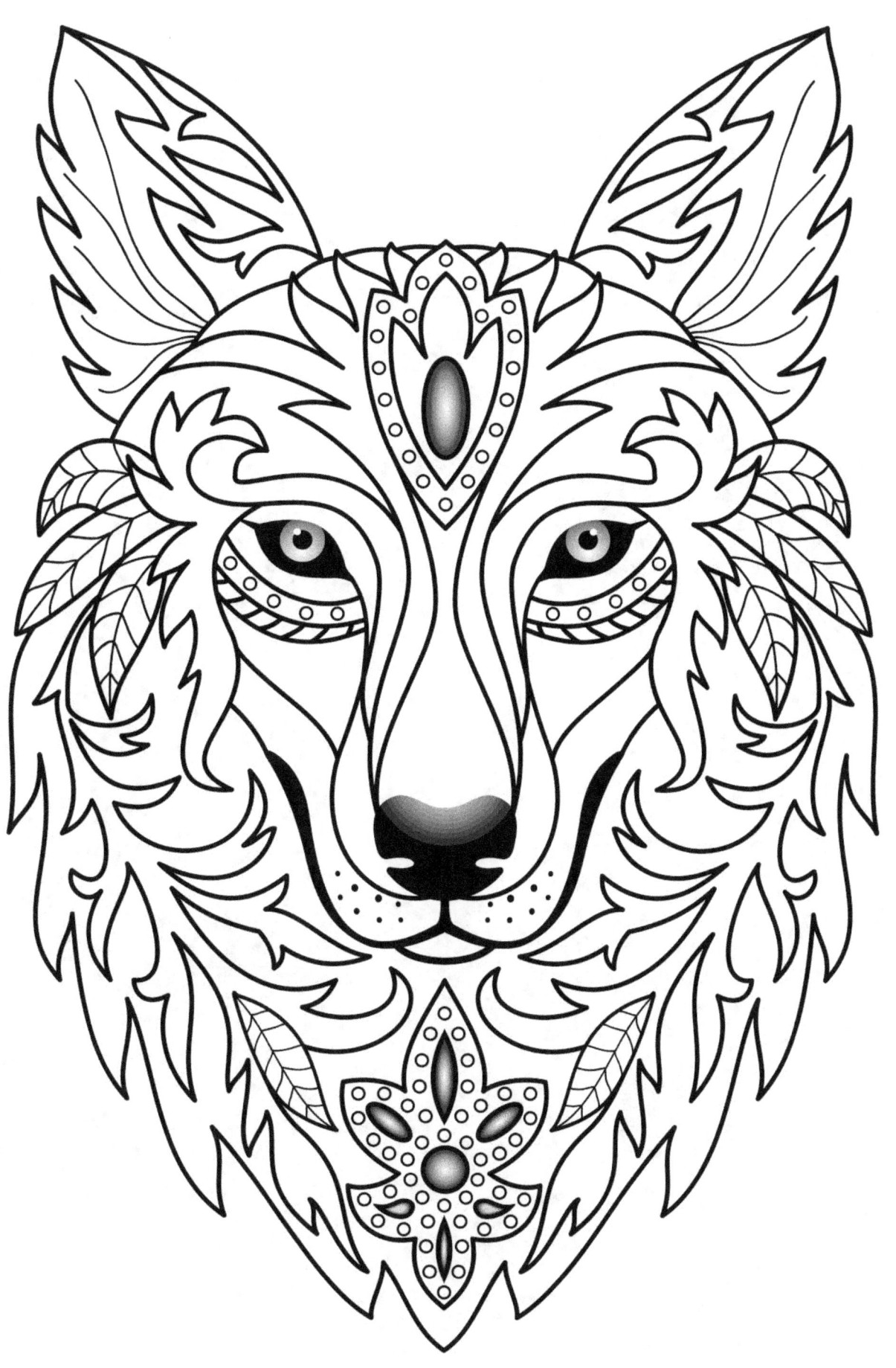

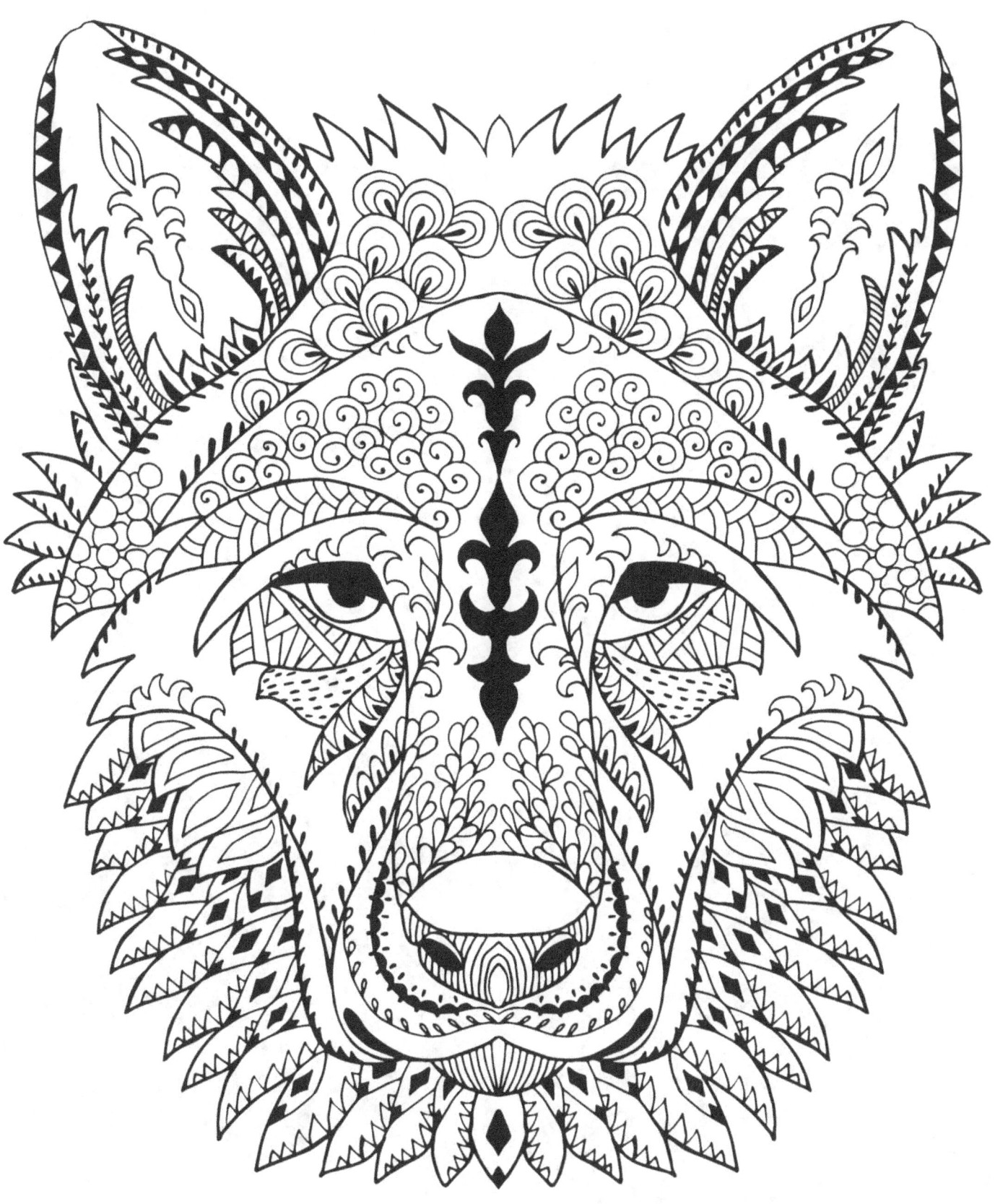

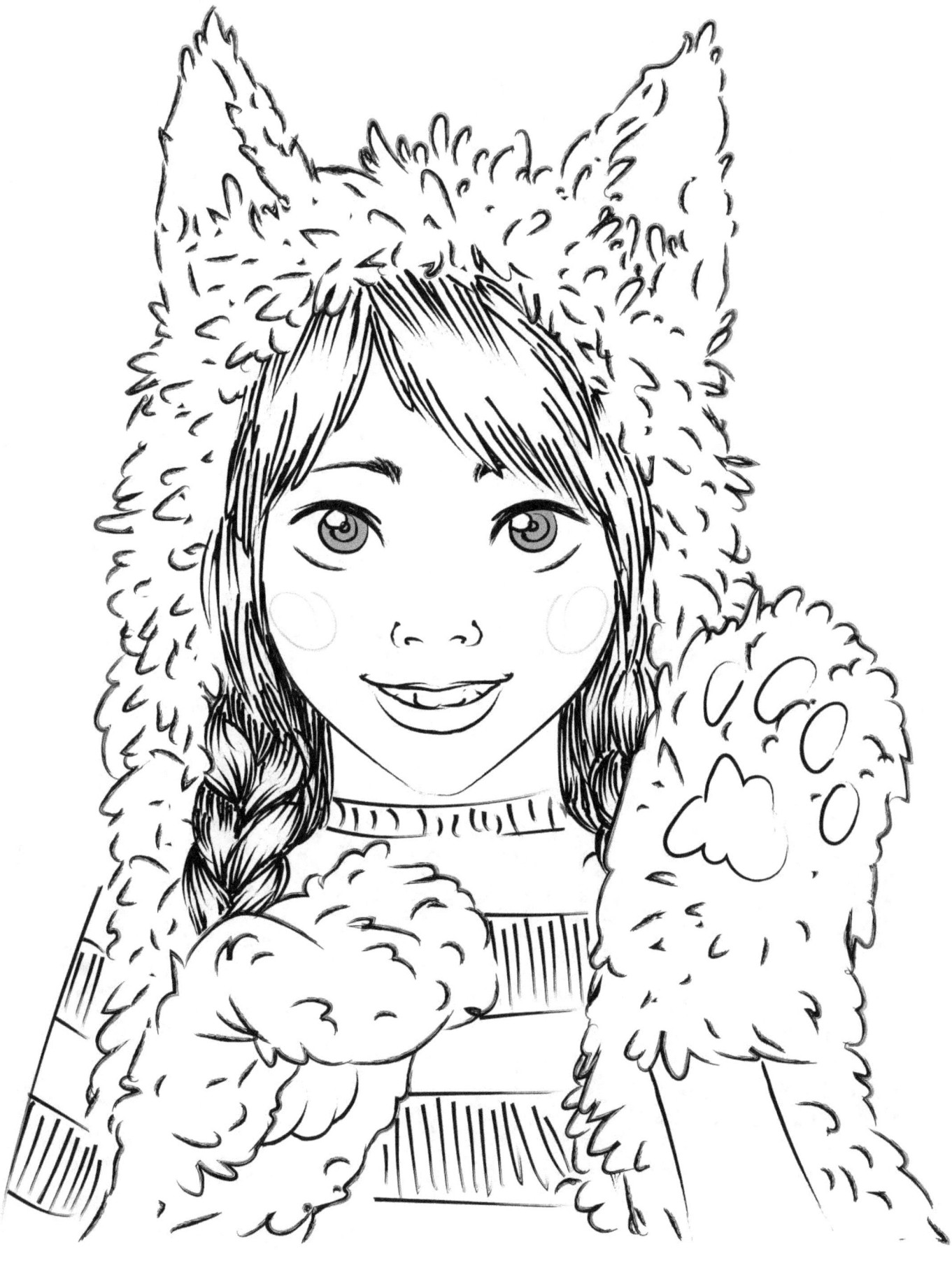

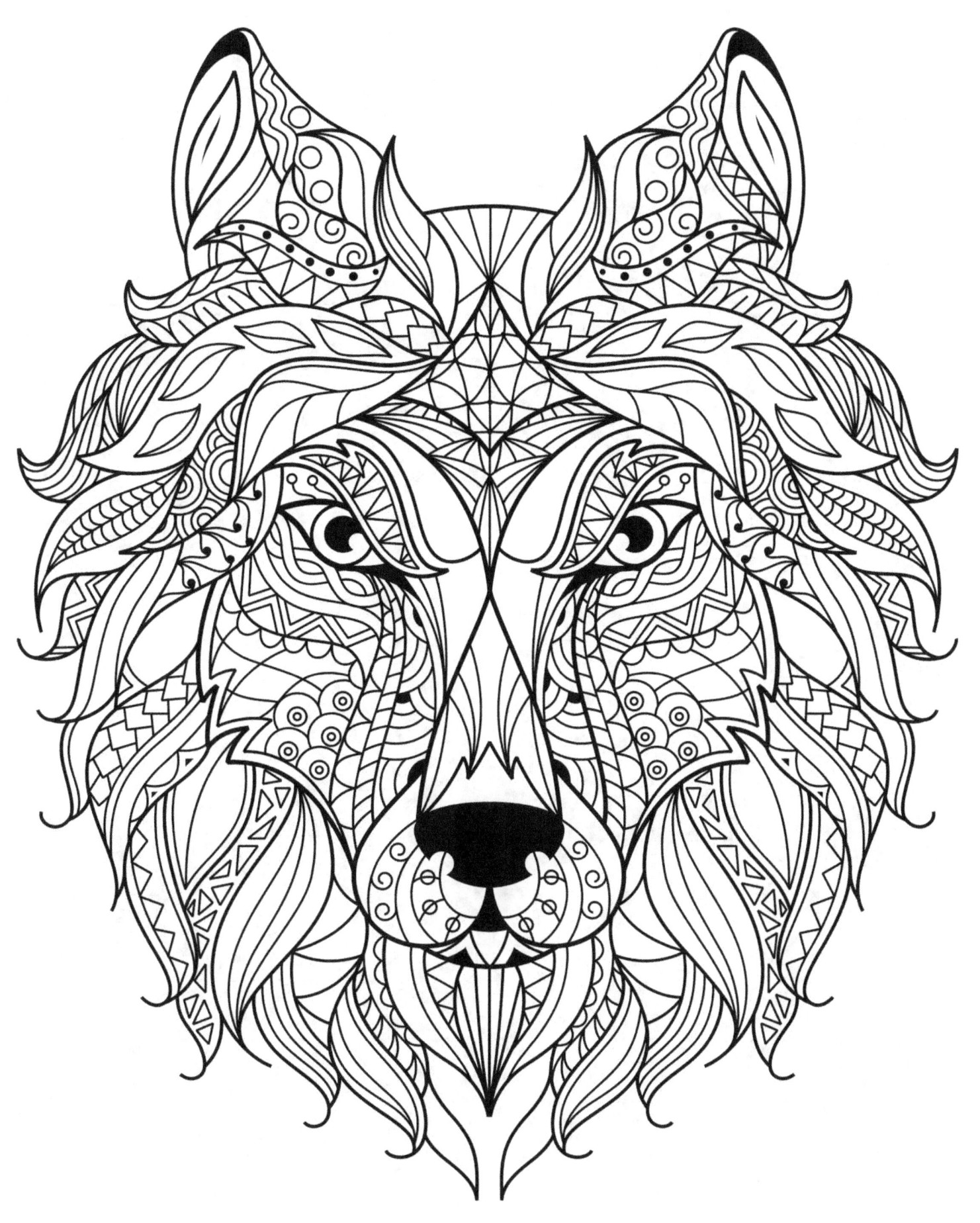

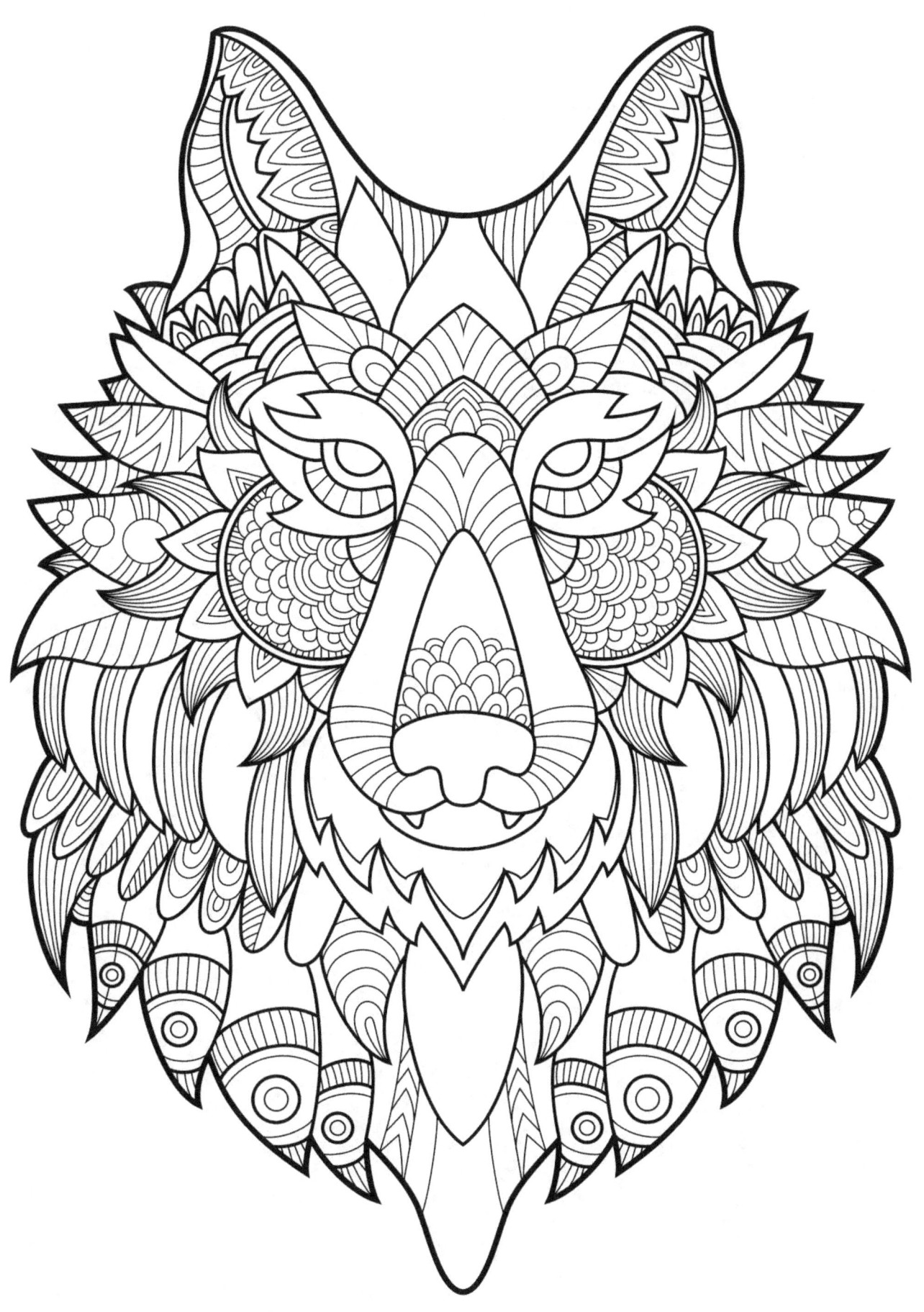

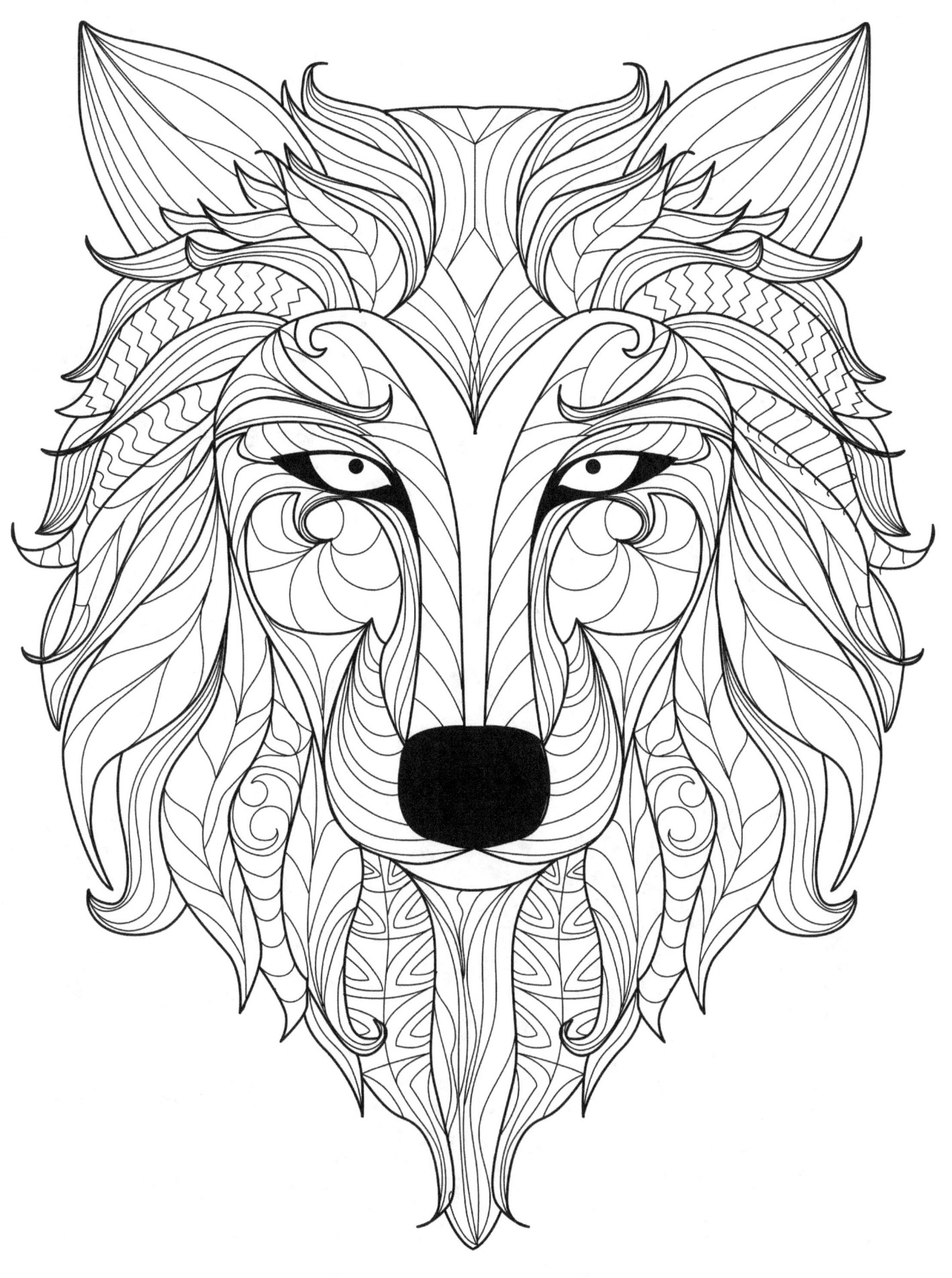

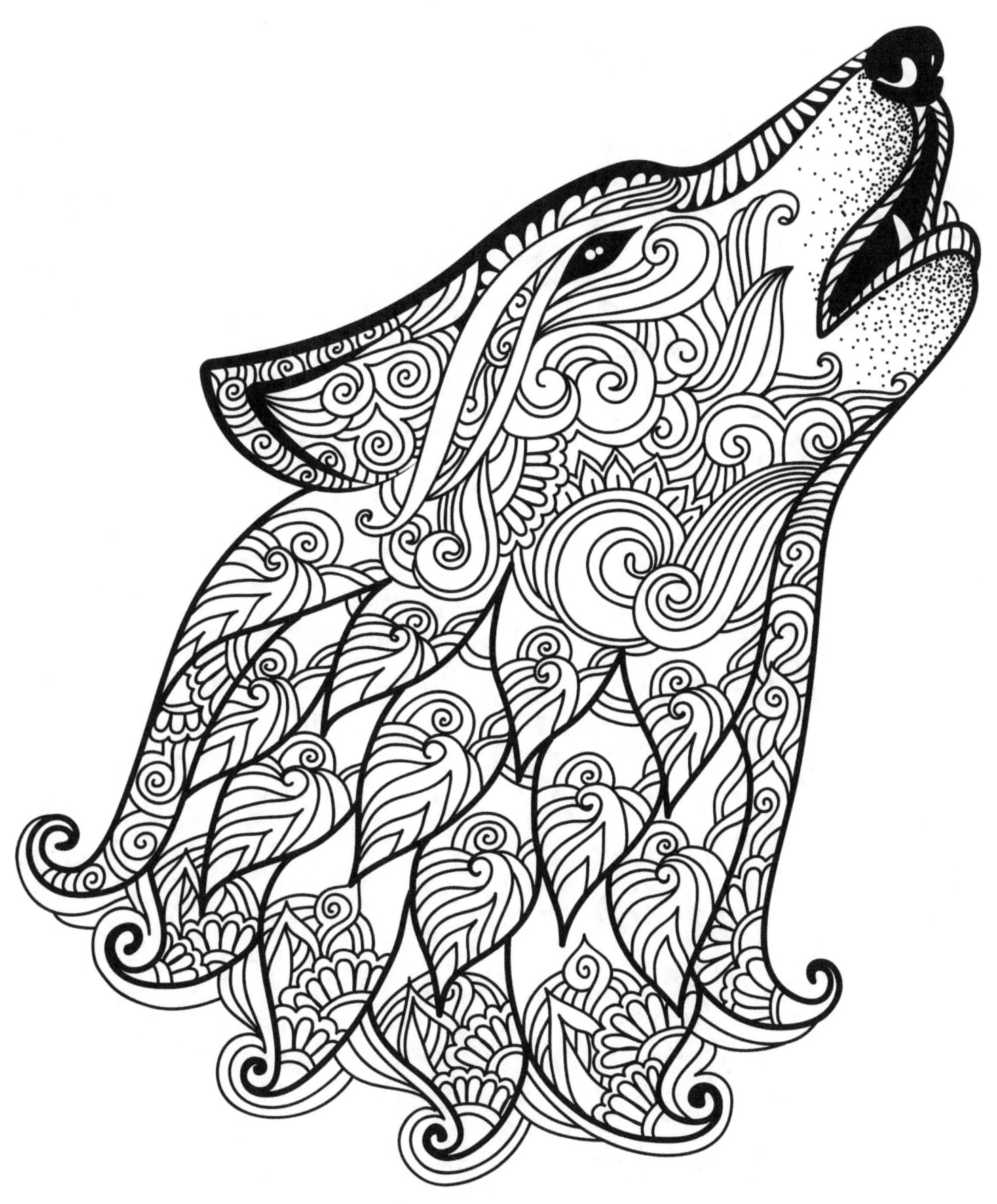

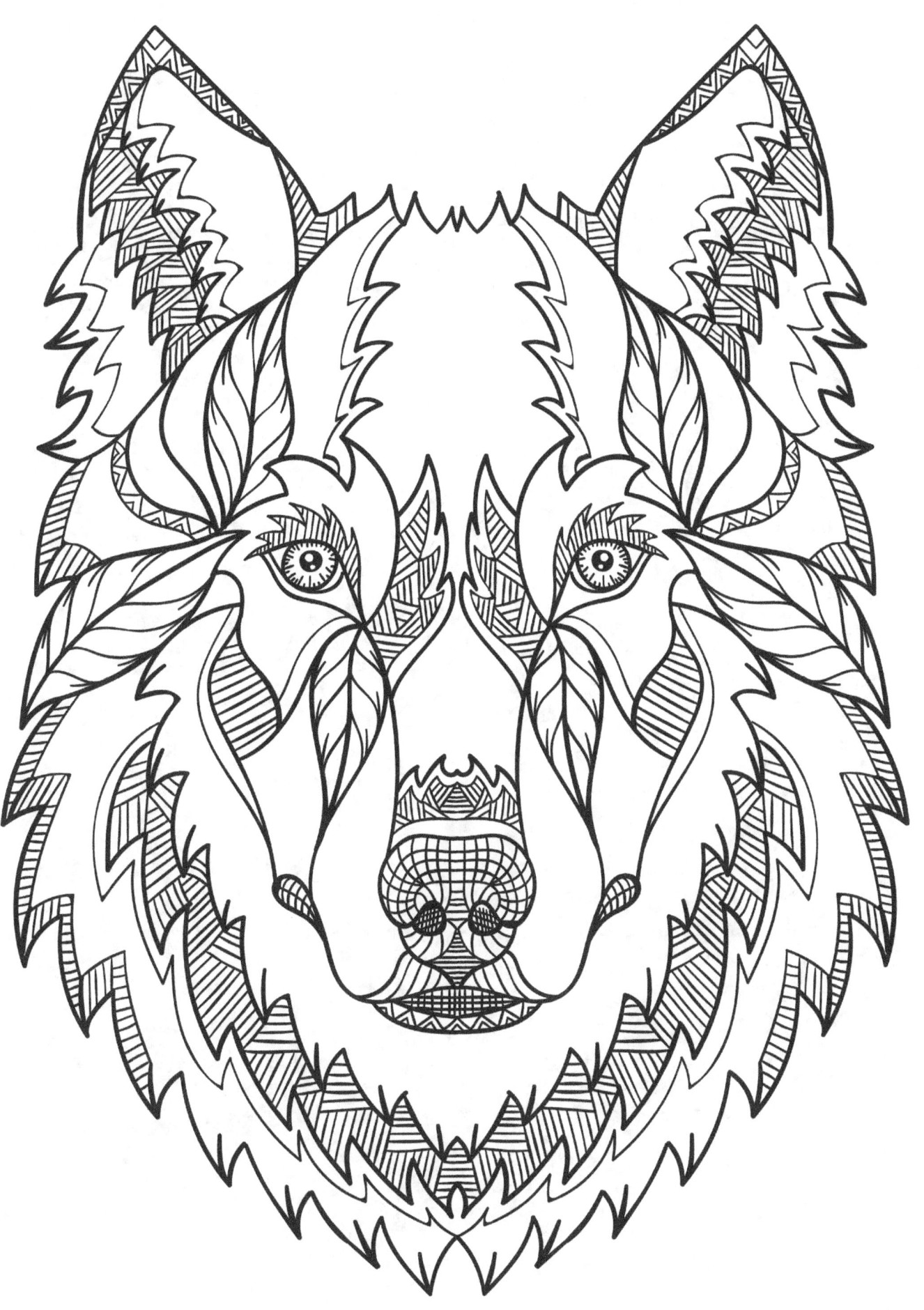

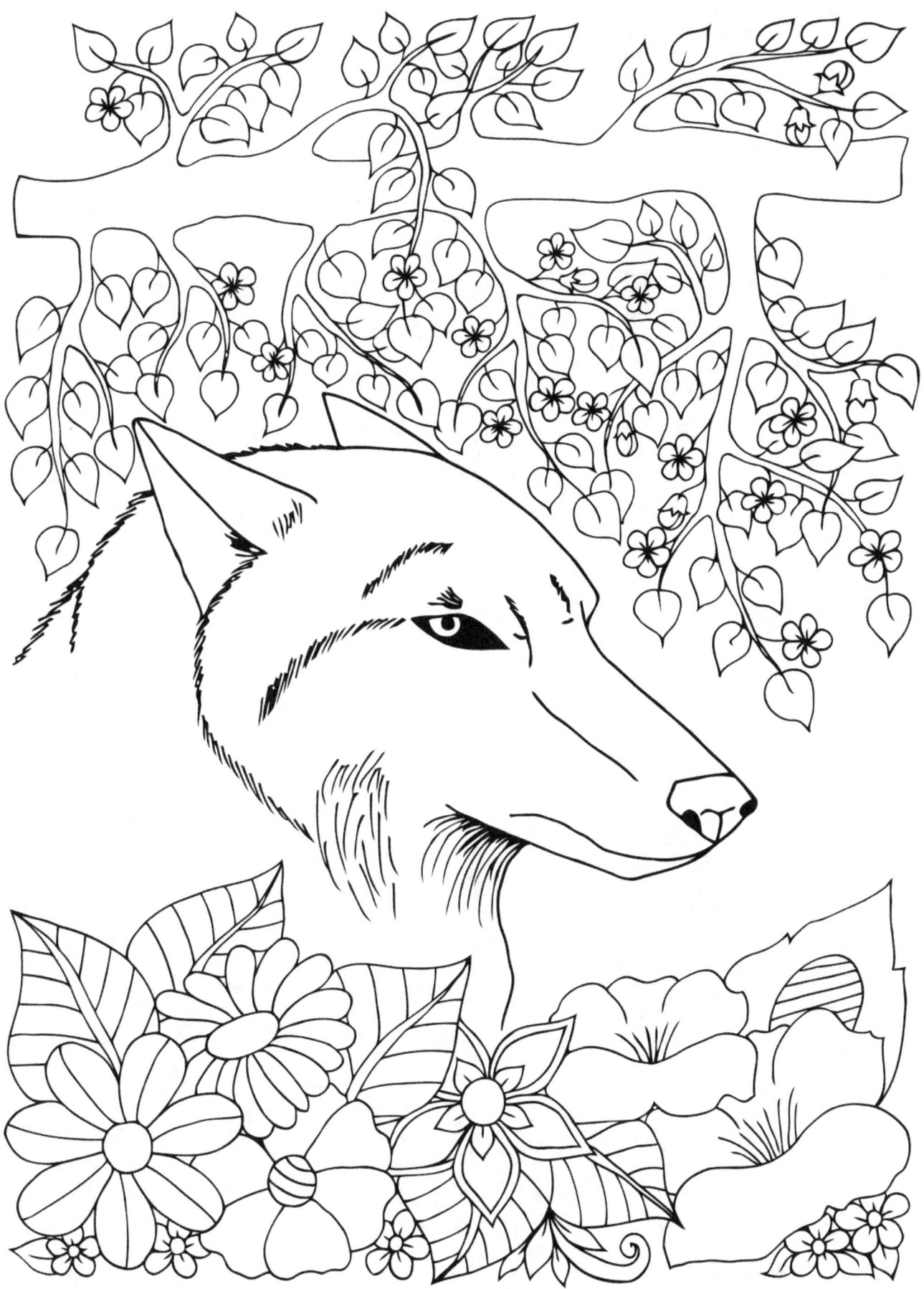

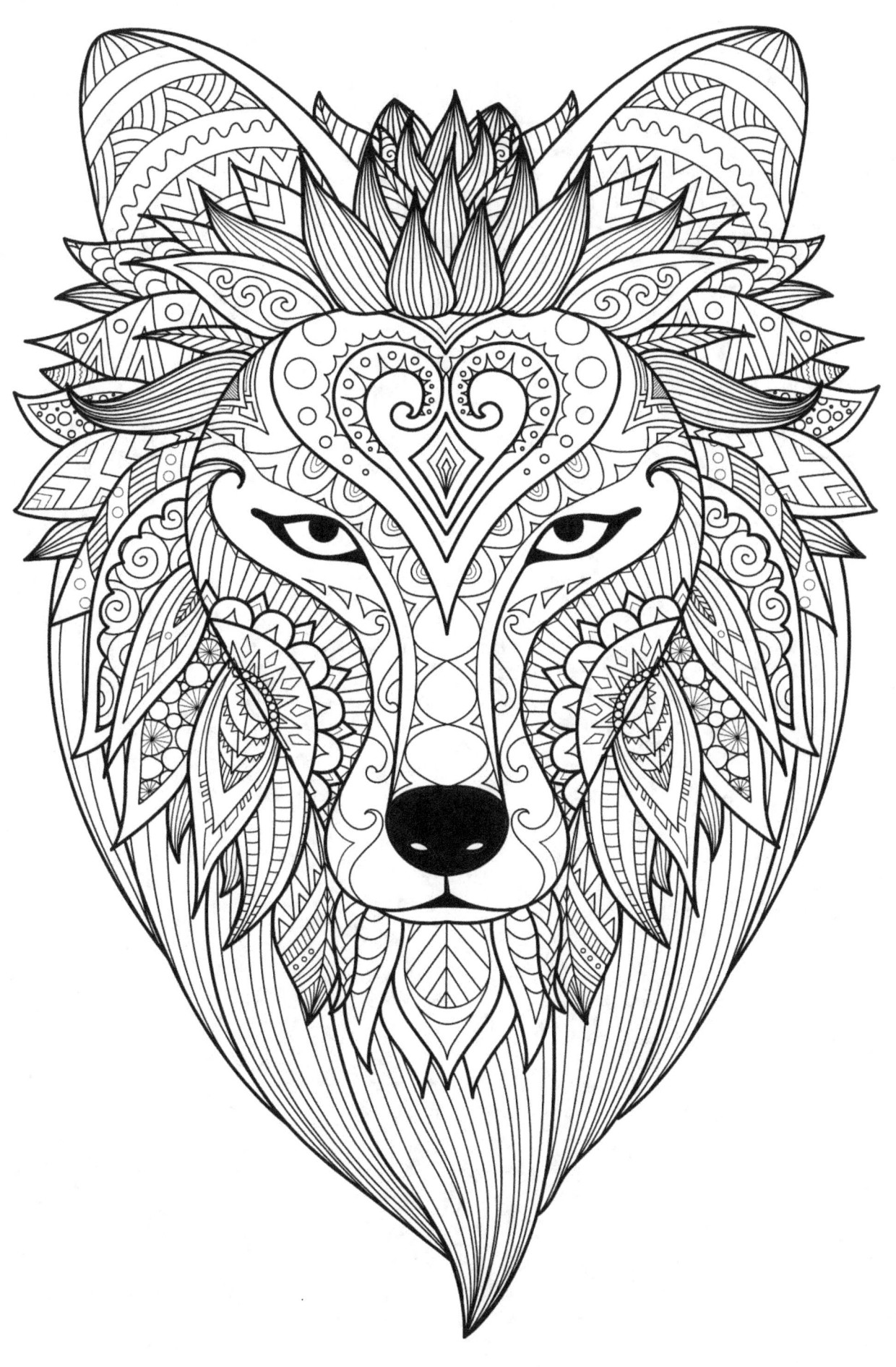

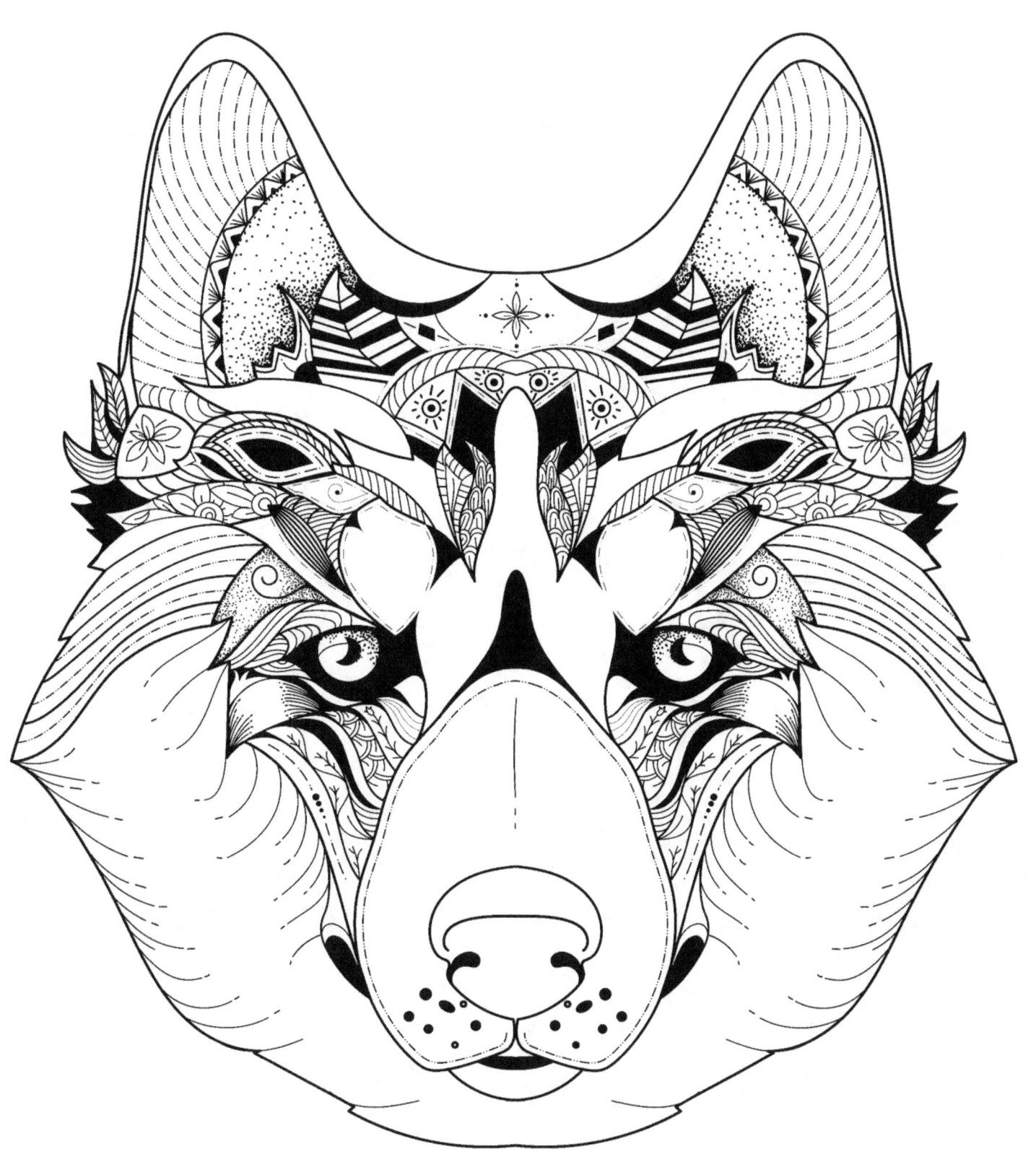

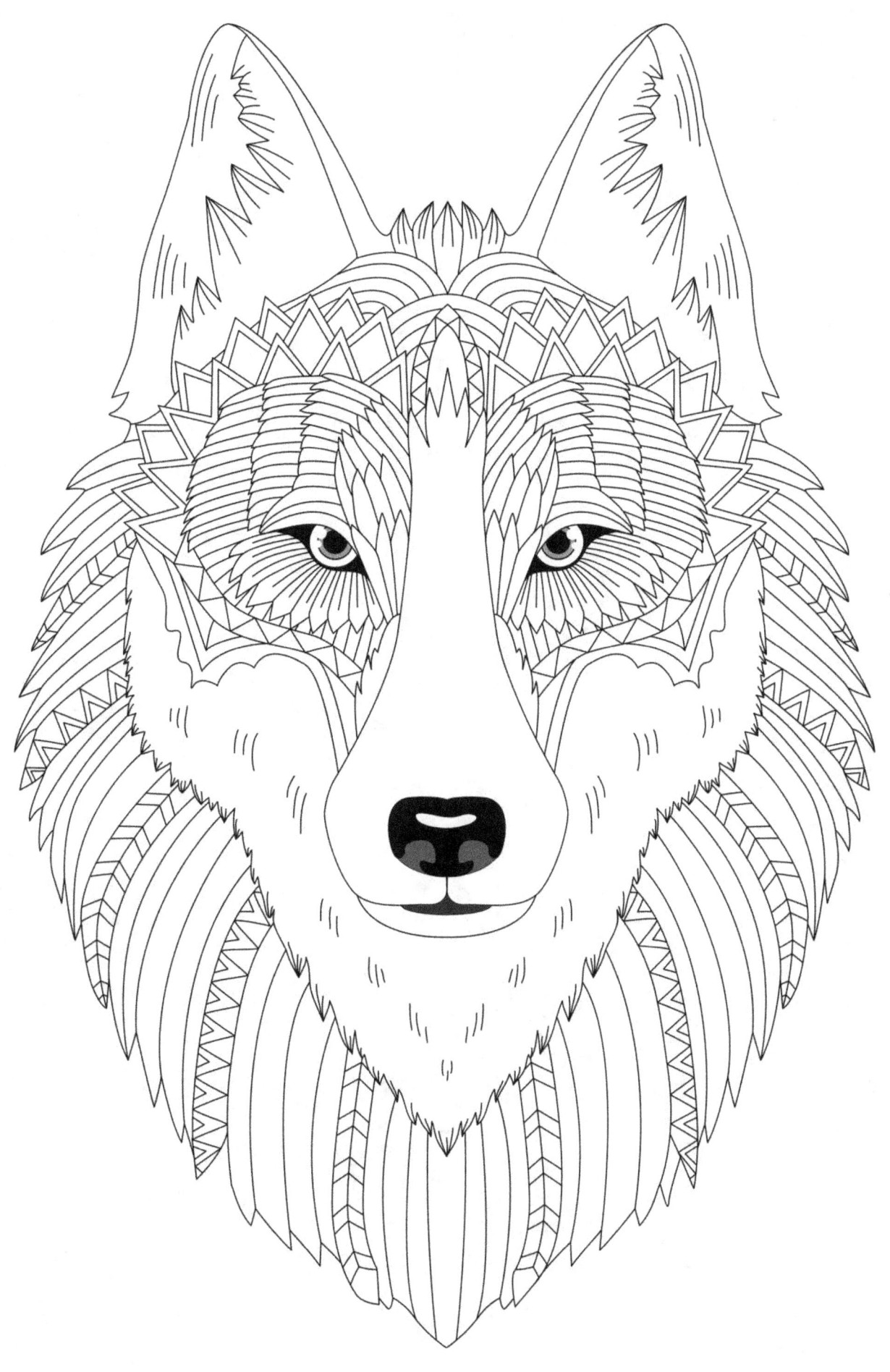

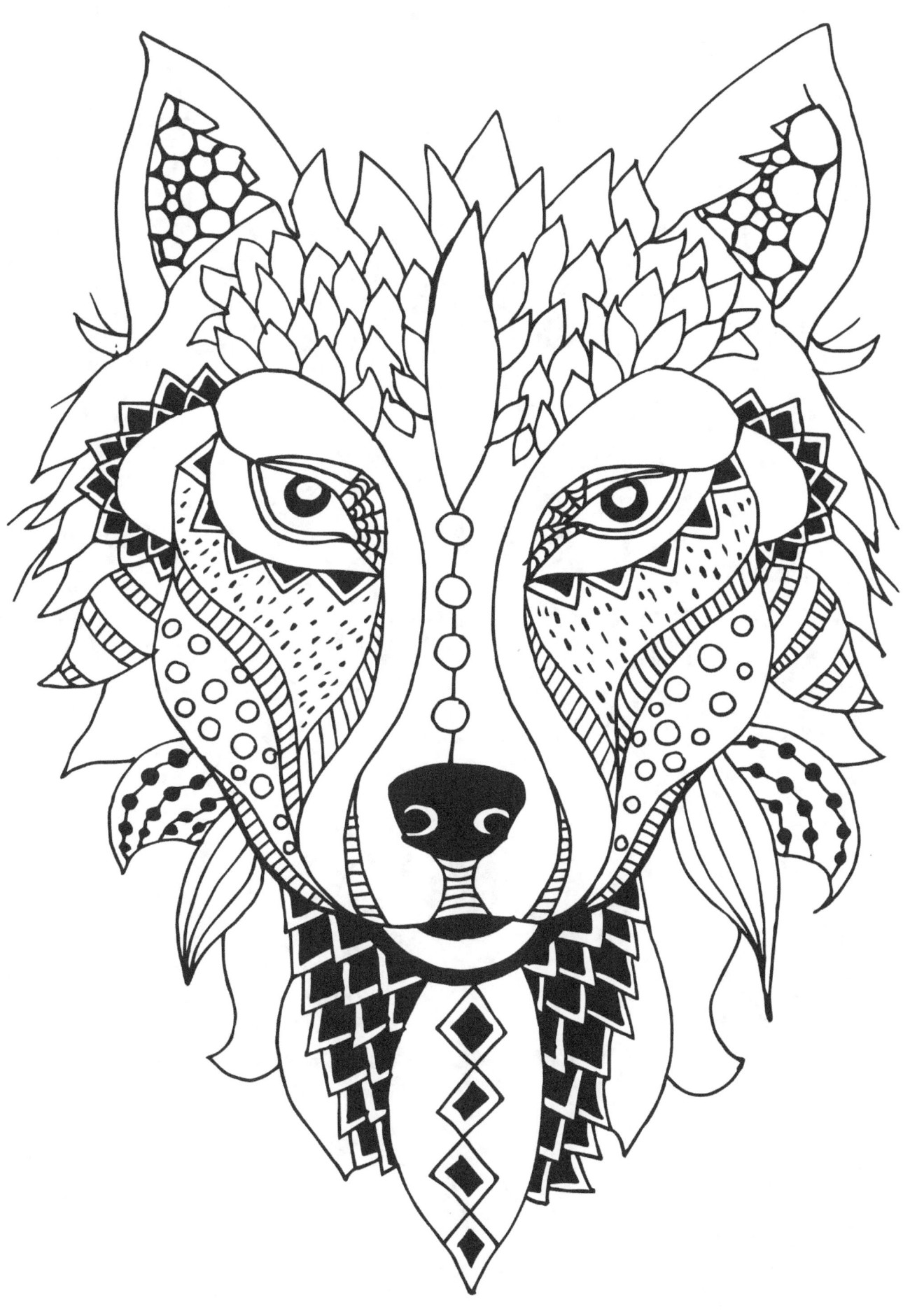

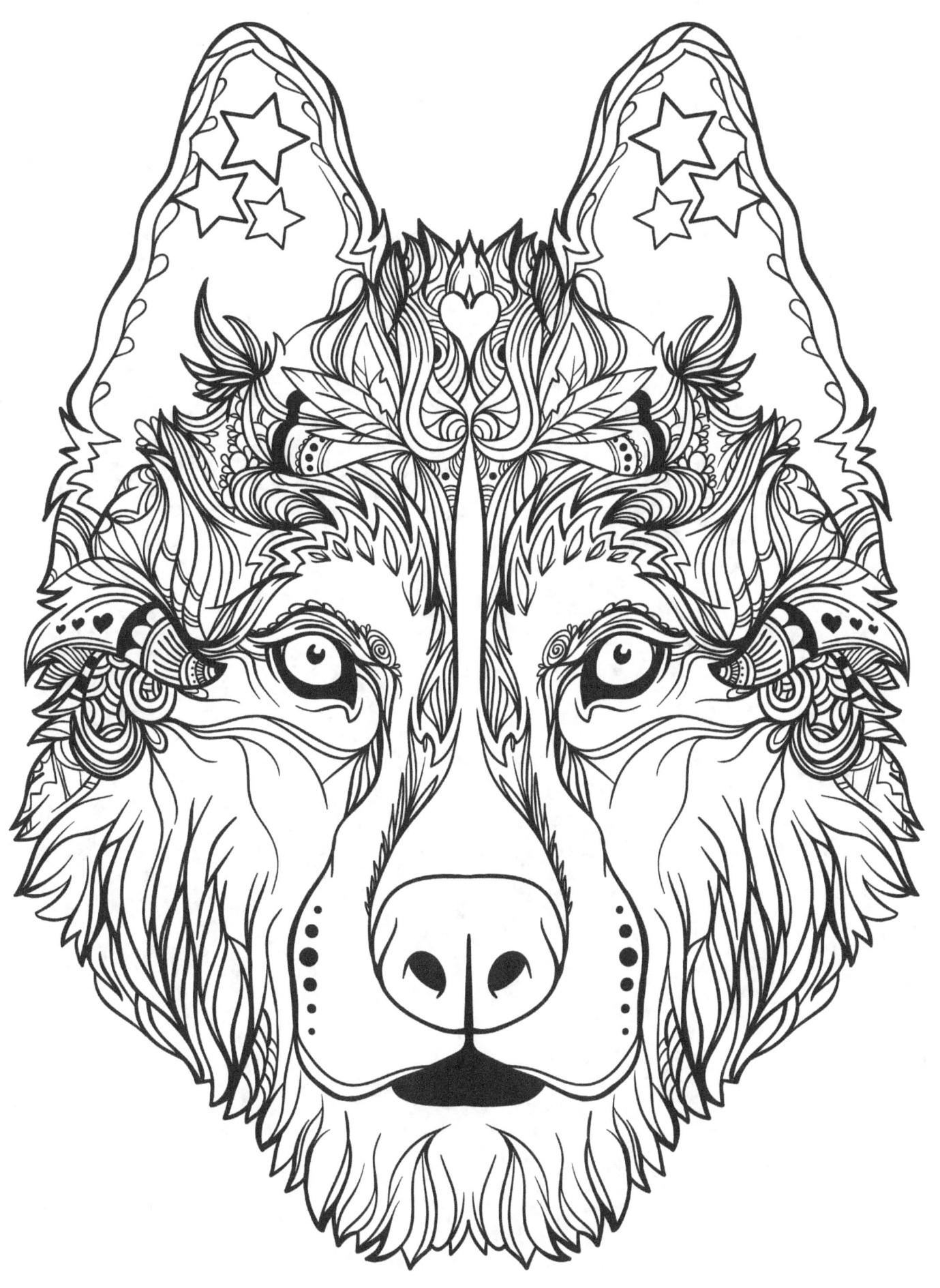

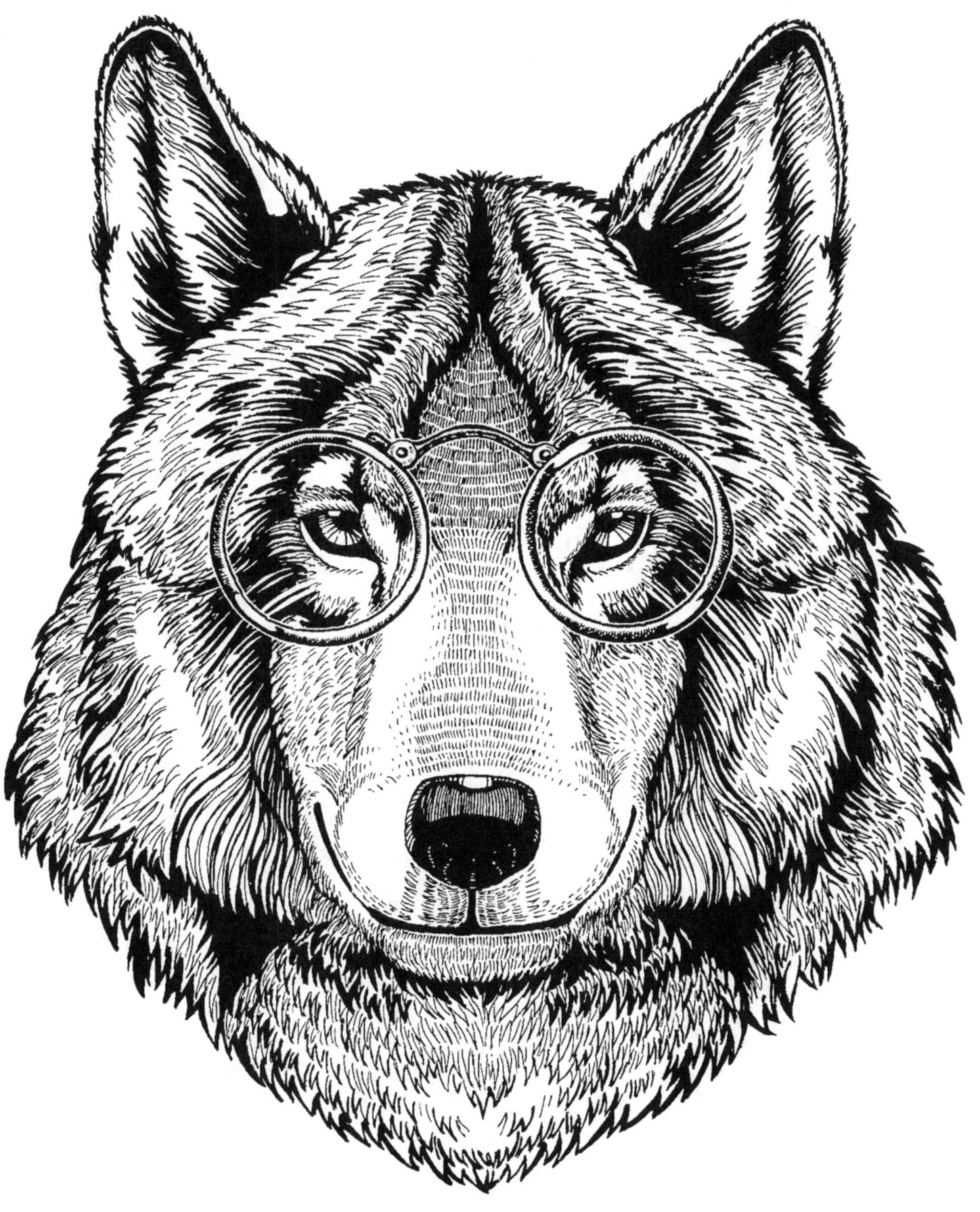

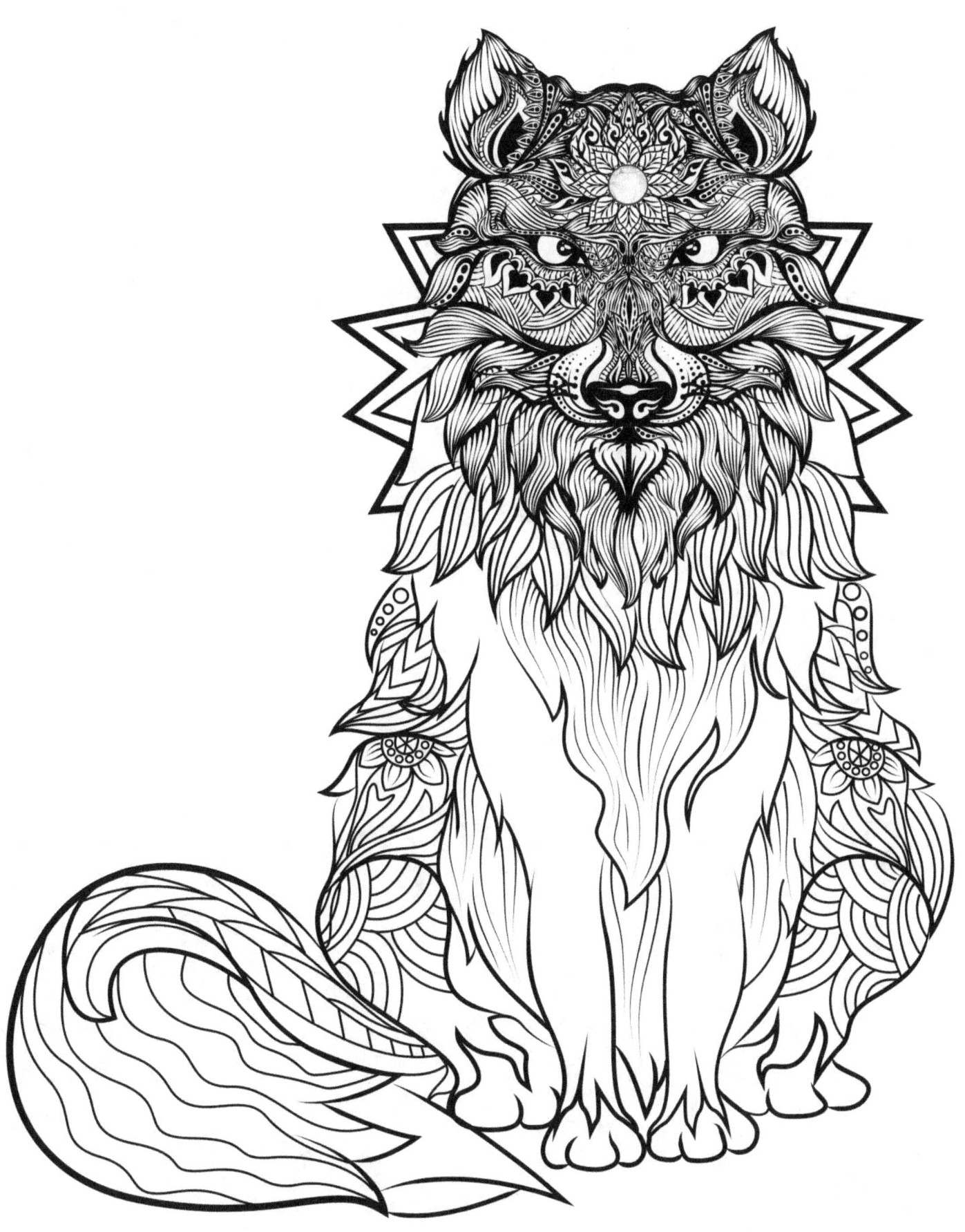

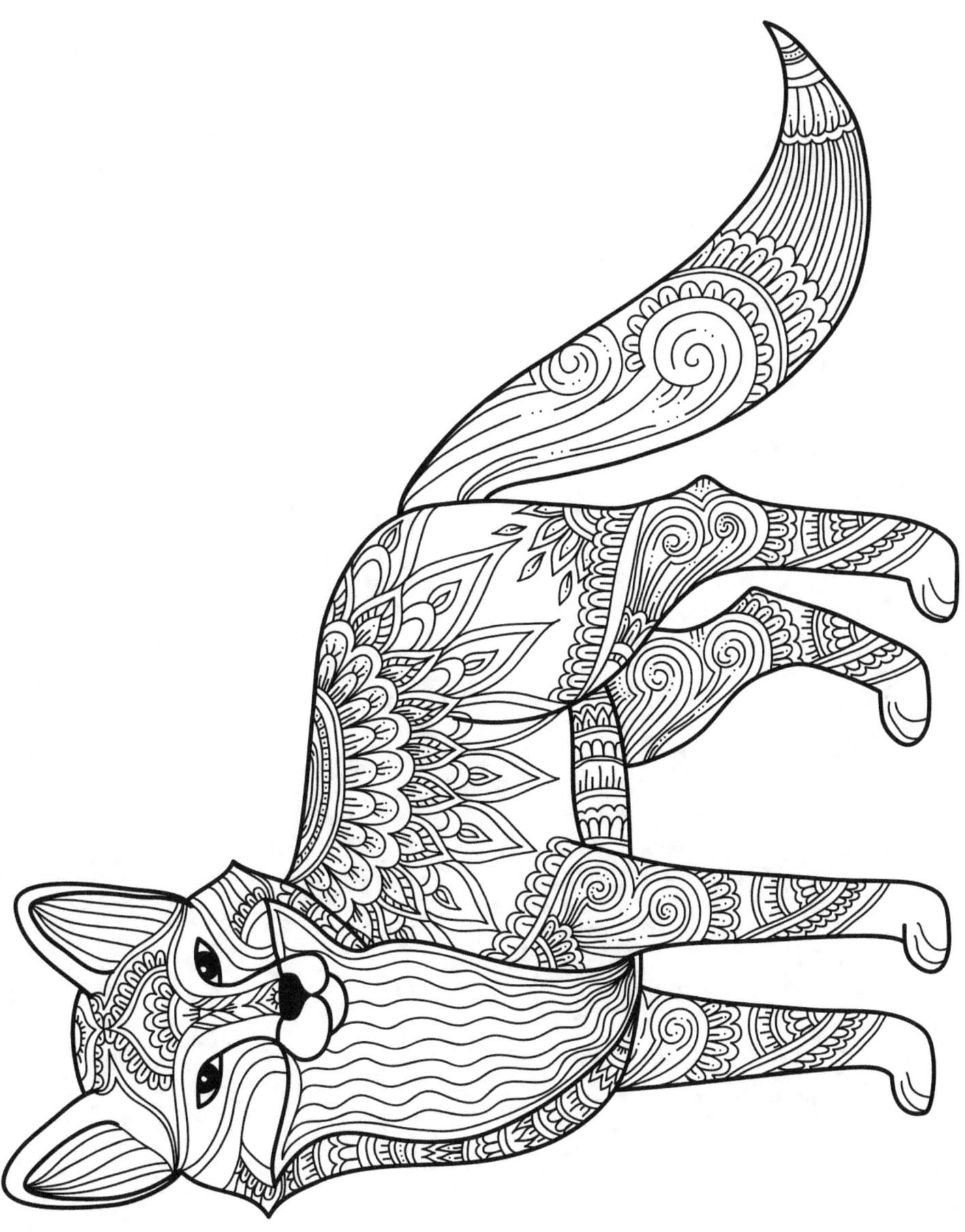

www.ingramcontent.com/pod-product-compliance
Lightning Source LLC
Chambersburg PA
CBHW081307180526
45170CB00007B/2607